THE WESTERN ART OF
JAMES BAMA

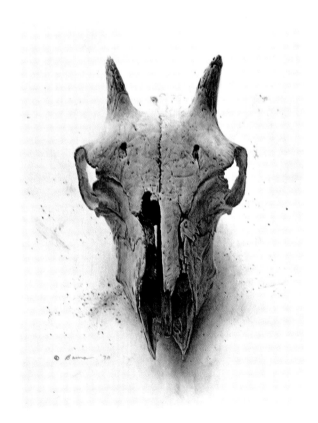

Cover Illustration

KEN HUNDER, WORKING COWBOY—A team roper at the
Stampede grounds, Cody, Wyoming, prior to the premier of
"The Great American Cowboy," a film about rodeo life. It was a
rainy, miserable day in September and he was waiting his turn
to rope. I approached him near the chutes and remarked that he
sure looked like a cowboy. He smilingly looked down at me and
said, "Well, that's what I am." He is typical of cowboys who
enjoy competing in rodeo events when not working their ranches.

THE WESTERN ART OF JAMES BAMA

Introduction by Ian Ballantine

A Peacock Press/Bantam Book
Toronto • New York • London

AN ORIGINAL PEACOCK PRESS/BANTAM BOOK

THE WESTERN ART OF JAMES BAMA
Copyright © 1975 by James Bama
All rights reserved under International and Pan-American Conventions

Library of Congress Catalog Card No. 75-7782
Hardcover SBN 0684-14410-7

PRINTING HISTORY
First U.S. Edition: May, 1975
Hardcover Edition: July, 1975

Book Design by Robert Blanchard

Hardcover edition published by Charles Scribner's Sons,
by arrangement with Peacock Press, a division of
Bantam Books, Inc.

Limited edition prints have been produced of
the cover painting, KEN HUNDER, WORKING COWBOY
and of Plate #39, SHOSHONI INDIAN CHIEF
by the Greenwich Workshop, 270 Mason Street,
Greenwich, Conn. 06830

Bantam Books are published by Bantam Books, Inc. Its trademark,
consisting of the words "Bantam Books" and the portrayal of a
bantam, is registered in the United States Patent Office and in
other countries. Marca Registrada.
Bantam Books, Inc., 666 Fifth Avenue, New York, New York 10019

Published simultaneously in the United States and Canada

PRINTED IN THE UNITED STATES OF AMERICA

INTRODUCTION

A native New Yorker, born, raised, educated and trained in the metropolis, James Bama never expected to change a life-style that was wholly city-oriented. With eighteen years of work behind him, his commercial career in big-time illustration was secure. Then, in 1966, he spent a vacation in Wyoming at the guest ranch of a fellow illustrator and got an idea of how different his life might be. The following year Jim and his wife Lynne went back to Wyoming and within two years thereafter they were starting their new life in a home thirty-six miles from the nearest town.

For the first time Jim devoted steady time and energy to painting what he wanted to paint. Illustrations, done at night, were still important, for the serious work did not come easy. He spent as long as five and a half months on one painting. But eventually, in something under three years, enough paintings had accumulated to warrant taking the first plunge into selling.

Back in New York in May of 1971, James Bama trundled his eighteen paintings to galleries. The first day one was hung it was sold. Another dozen sales in several months convinced Bama he could retire from commercial illustration and officially make his living as a fine artist, painting what he wanted to paint, living in the West. Bama says, "I once told my wife that my claim to fame in life would be my understanding and real liking of people rather than my ability to paint. In order to paint the things I do you really have to like people and be able to know them and work with them and know when to be quiet and when to respect them. People are really what interests me and art is a way of expressing it."

Because Bama is a realist, he is often compared to one of the best known realistic artists. His reaction to this is: "Basically, I'm flattered. I'd rather be compared with Wyeth than any other living artist . . . but just as I always wanted to paint like Norman Rockwell, I never wanted to do the same subject matter. All I ever wanted to do was something of comparable effort and sensitivity to what Wyeth does, but not his subject matter or medium. I work in a different medium." Yet he never thought of himself as being a "western" artist and indeed, does not consider himself one now. "But," as he says, "what a wonderful source of inspiration and material I have found to say what I wanted to say about life and work and what I believe in."

Ian Ballantine.

1) SHEEP SKULL IN DRIFT—Went with a friend, Bob Edgar, who is re-creating an old western town called "Trail Town," and helped load some old wagon wheels. It was at an old cow camp where there was a one room school house with a sod roof. This sheep skull was on it, and Bob gave it to me in return for my help. Set it out in the snow at home and waited for a good drift.

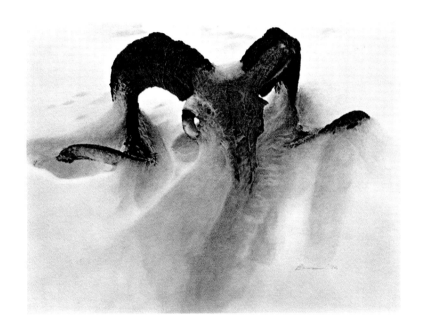

2) ROY BEZONA, PORTRAIT—Roy was a great old guy who was part of the past. He was cowboy, sheepherder, homesteader, helped to build the roads in Yellowstone Park and was a hero of World War II. A wonderful man, whose friendship had to be earned, not bought.

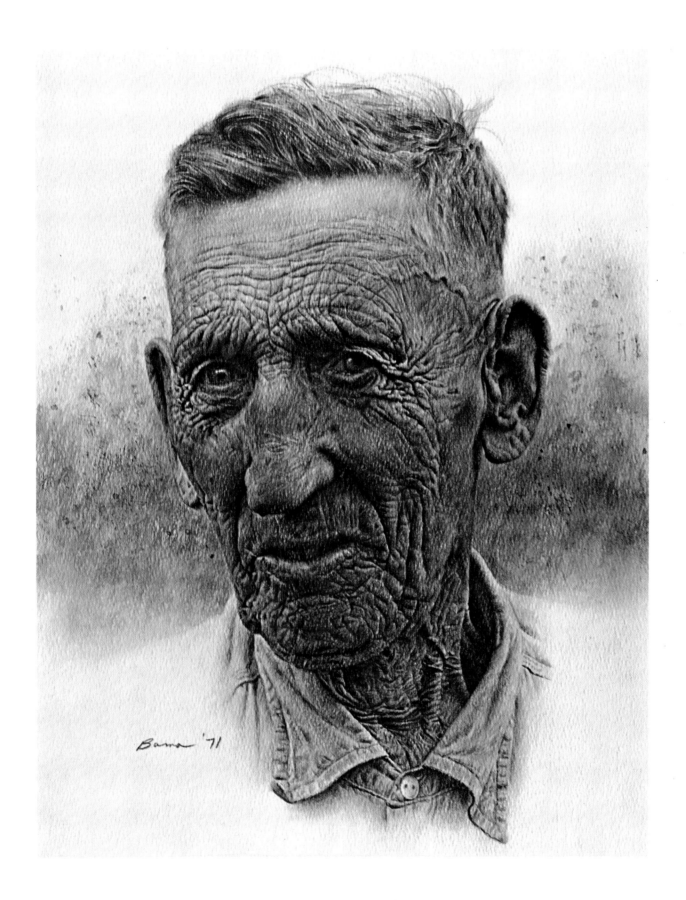

Bama '71

3) HENRY WESTERMAN, PORTRAIT—an old time cowboy who is
 82 and still rides horseback and is a wonderful old guy.

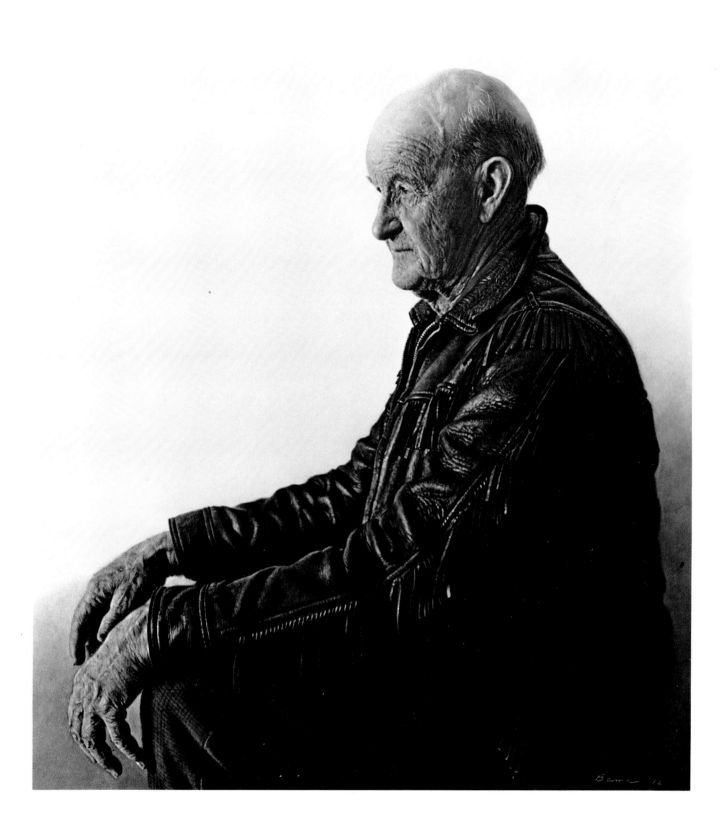

4) ROY BEZONA, OLD MAN WYOMING—Roy was born July 10, 1890, the same day Wyoming became a state, and he asked me to give this painting this title.

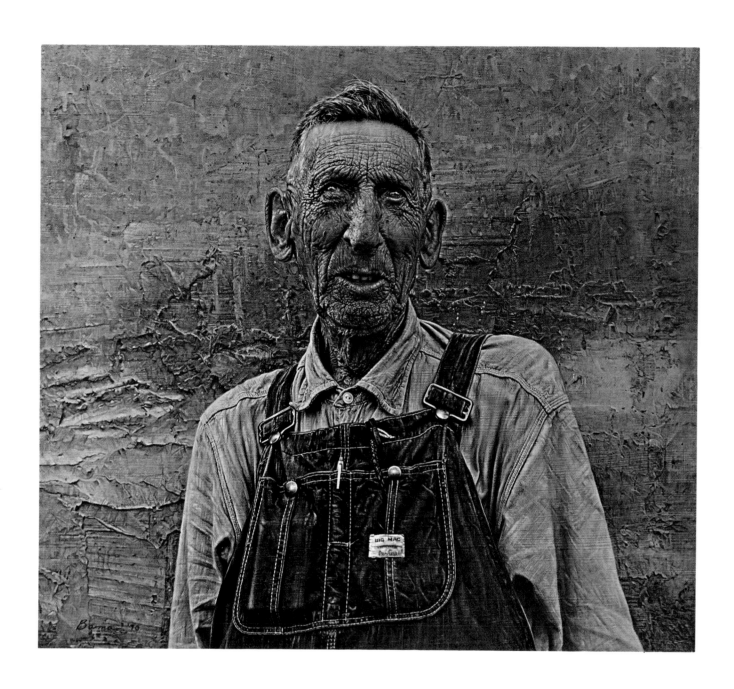

5) TOM LAIRD, PROSPECTOR—A real living prospector who also cuts firewood for a living. He won a purple heart in World War II and again in Korea and thought the army surplus pack he wears to gather stones would be appropriate and place him in contemporary time.

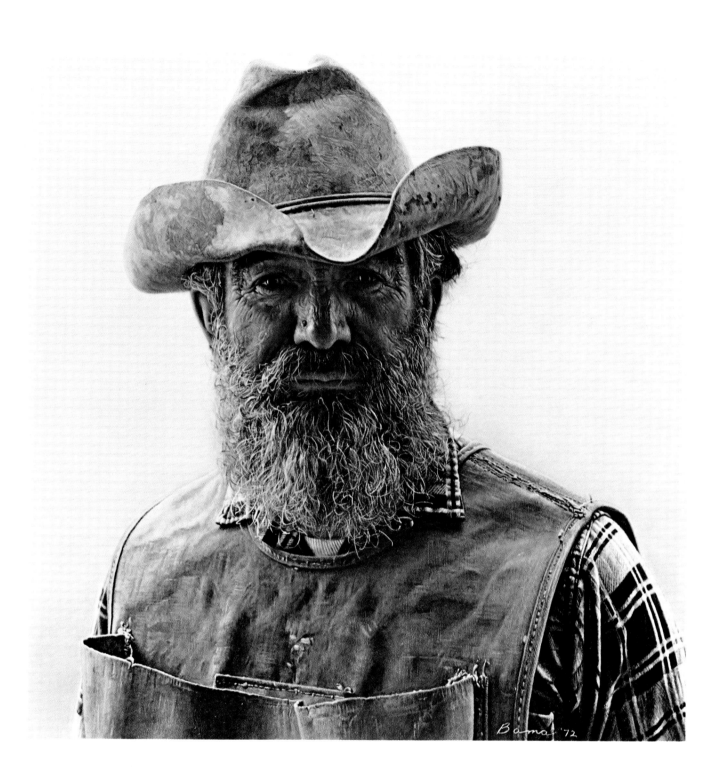

6) OLD BUFFALO SKULL—There are still old skulls like this to be found, if one knows where to look, and they date way back to the days of the Indian hunts.

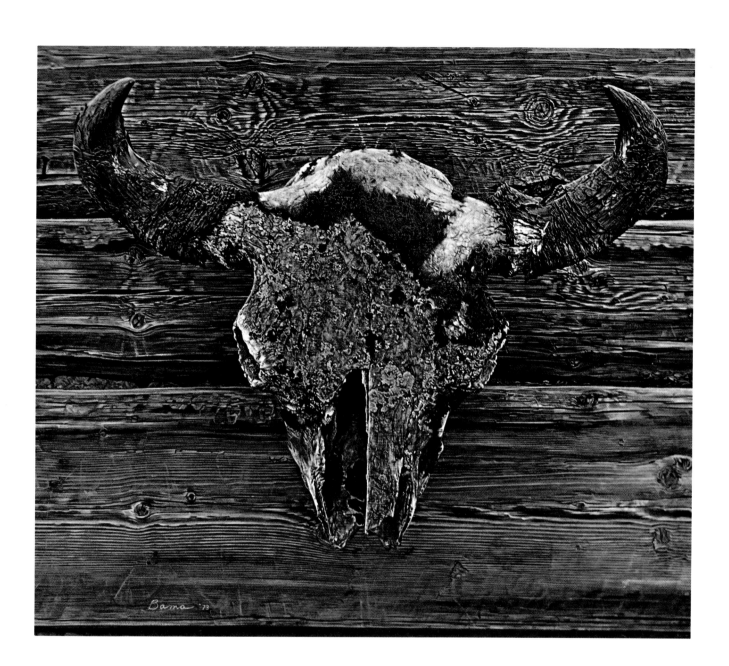

7) 1880's STILL LIFE WITH FRONTIER COLT

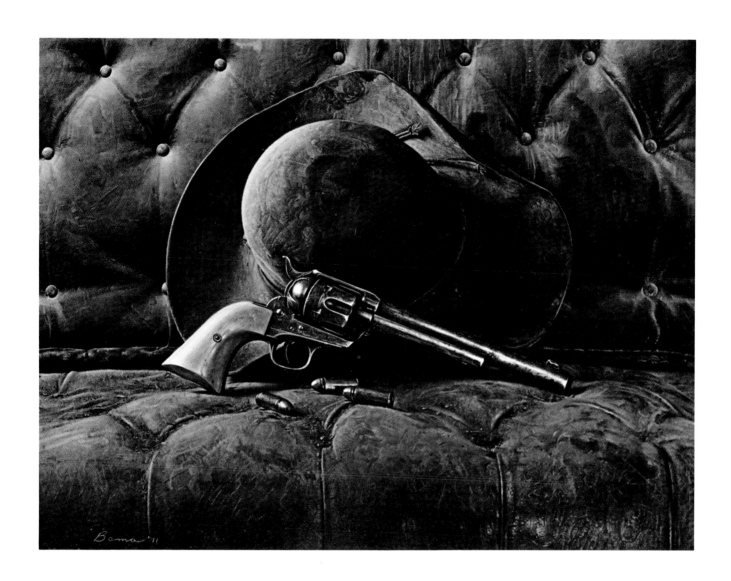

8) BOB EDGAR DEPICTING 1860's SCOUT—Bob is the creator of Old Trail Town in Cody, Wyoming, and a historian, archaeologist, gun collector, artist and shooting champion. His life's work is the past and I painted him accordingly. Outwardly he is very easygoing and calm, but I tried to portray him with the intensity he must have to live the life he has chosen. A symbolic portrait.

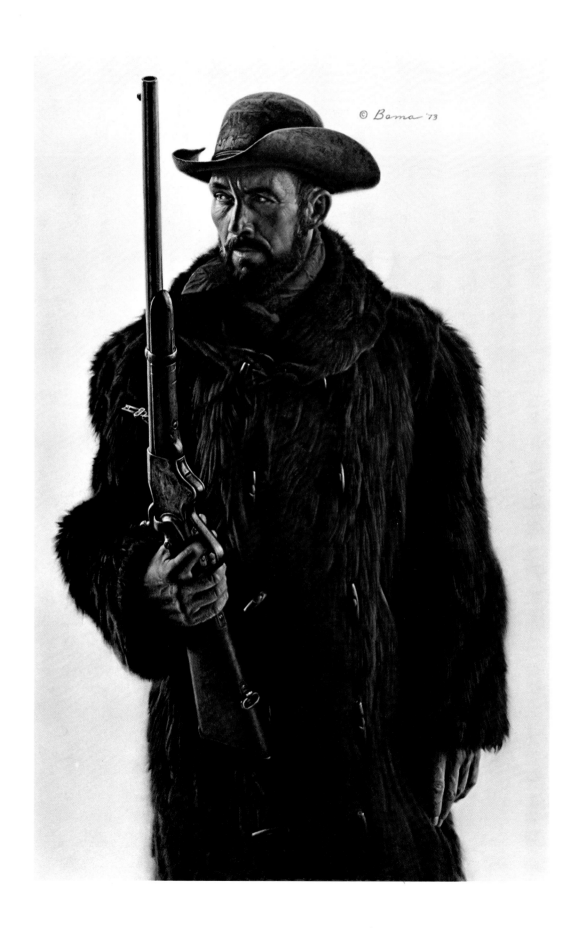

9) GEORGE WASHINGTON BROWN, STAGECOACH DRIVER—
He was 92 when I painted him, the oldest living 24-horse team
stagecoach driver in Wyoming. He was also a range detective.
I had him grow whiskers and portrayed him as an old time
freighter.

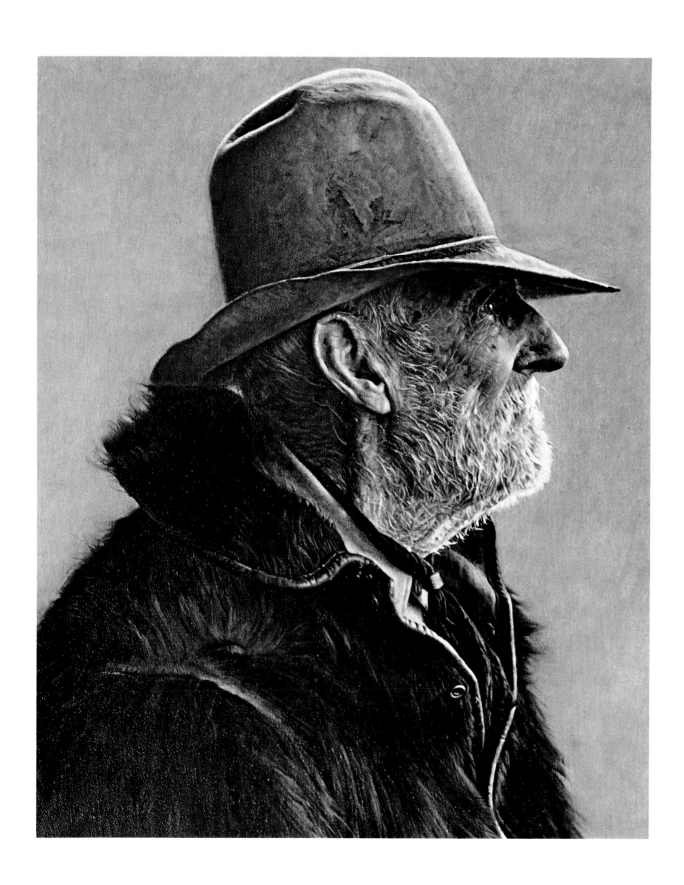

10) SLIM WITH SADDLE—An old time cowboy who reminded me of
 my impressions of cowboys from childhood in the 1930's. Waited
 three years before I conjured up the courage to ask him to pose.
 He is a classic of the type.

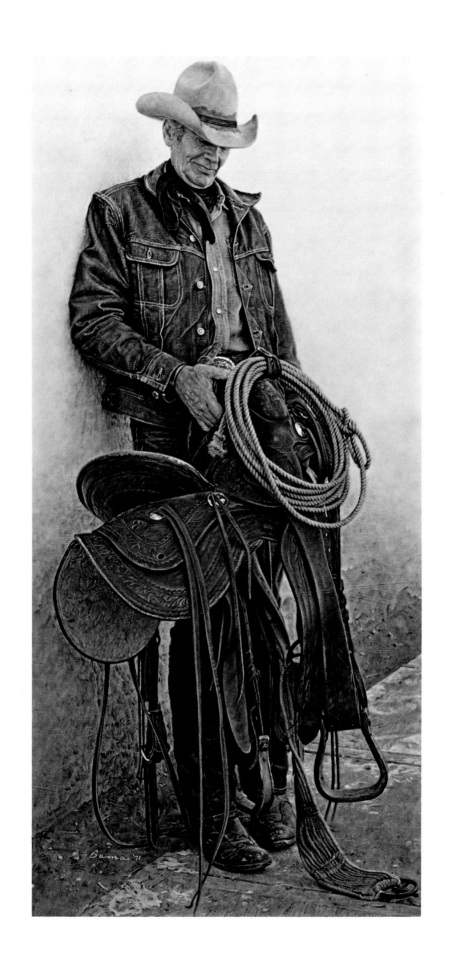

11) MOUNTAIN MAN, ANSON EDDY—A real modern day mountain
man, who lives with a woodburning stove and about forty cats
in his old cabin. He has no car and lives thirty-six miles from the
nearest town. His woodpile seemed like a wonderful setting to
pose him with.

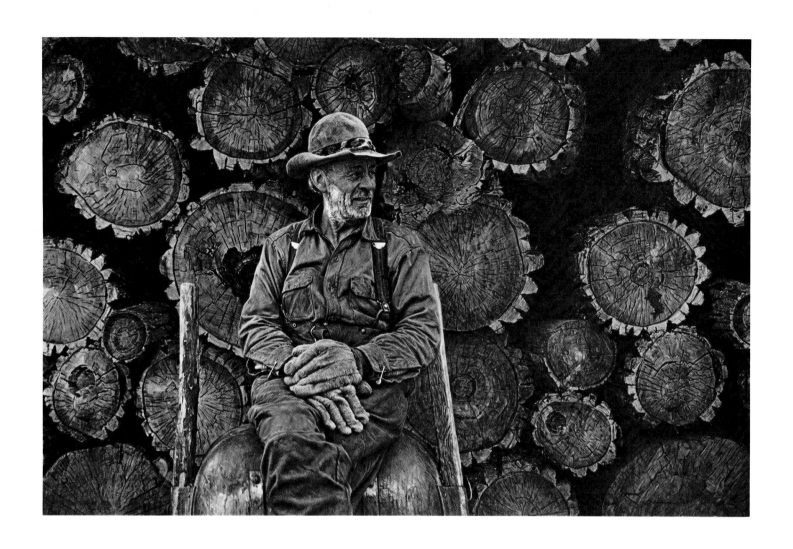

12) JACK BROWN—SOUTHFORK HILLS—Anson Eddy's good friend, who would bring him hay for his horses. They were old hunting buddies for years. He was a real straight square guy and I posed him that way.

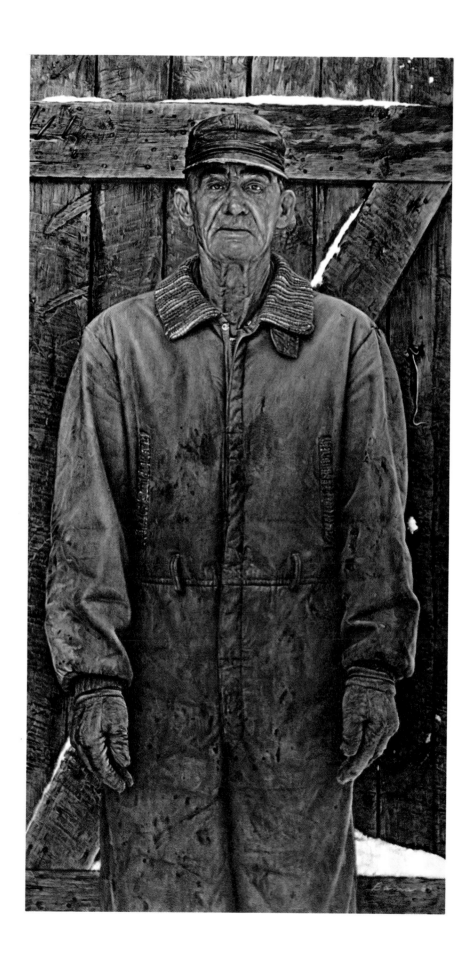

13) 1880's STILL LIFE OF SADDLE AND RIFLE

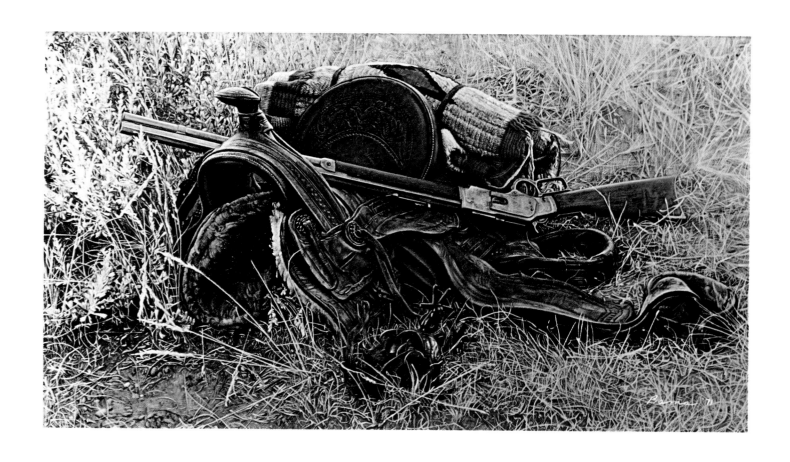

14) CHUCK WAGON IN THE SNOW—We lived on a ranch for two-and-a-half years and it was always a magic moment when the snow fell.

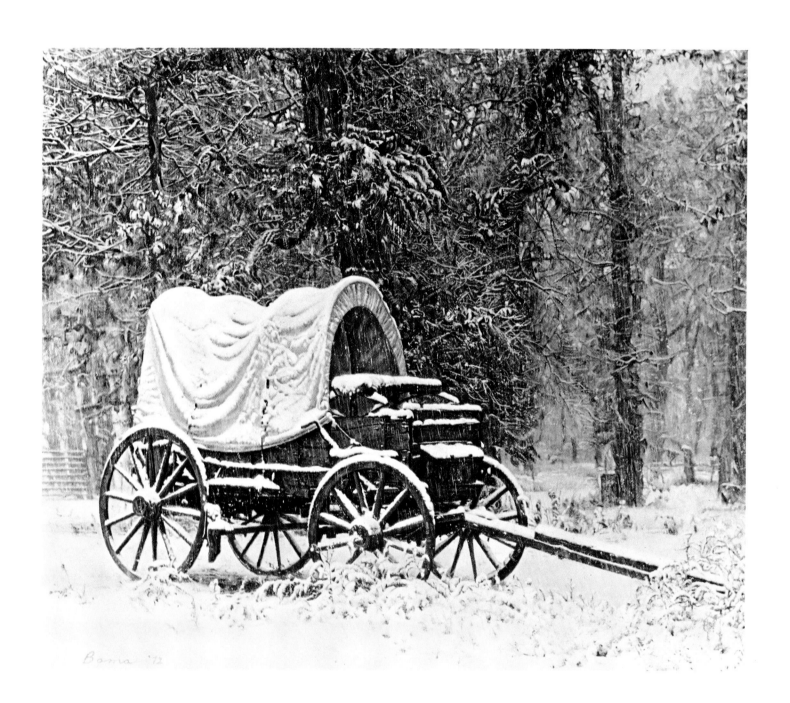

15) WORK SHED IN WINTER—Where all the repairs were done on the Circle M Ranch where we lived.

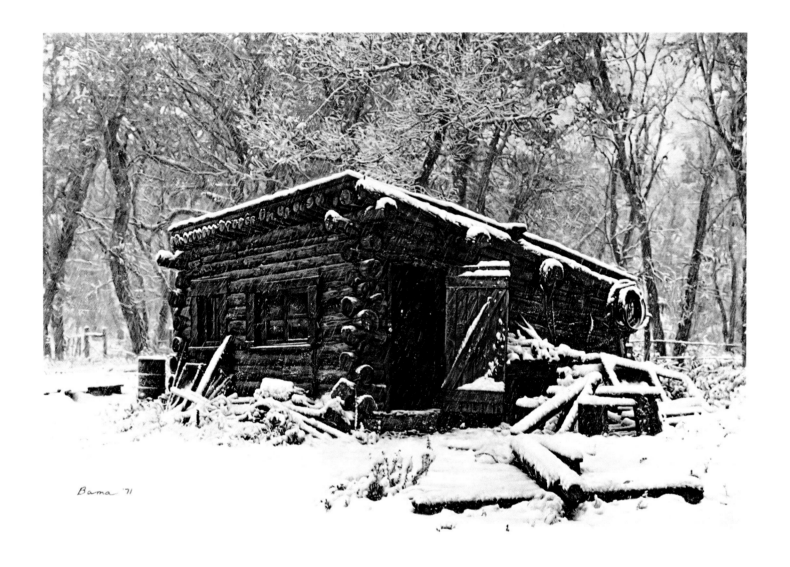

Bama '71

16) OLD CROW INDIAN SHIELD—A real old Indian shield with an eagle head on it, which I simply couldn't resist wanting to paint. Placed it on a buffalo robe, an appropriate setting.

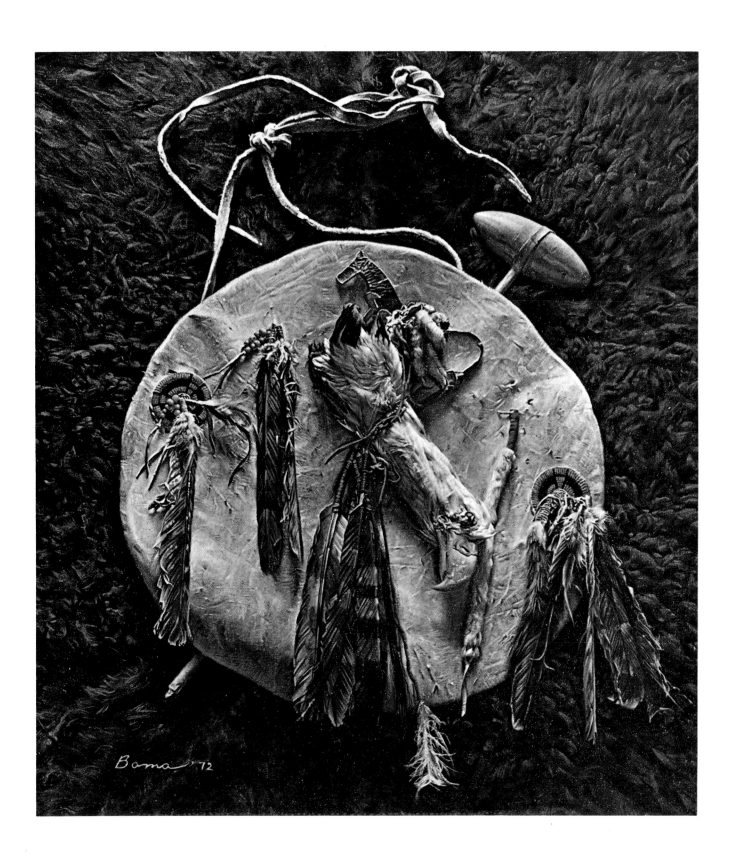

17) CHESTER MEDICINE CROW WITH HIS FATHER'S PEACE PIPE
 —The son of a famous Crow chief at the turn of the century. He
 is wearing a peace medal given his father by Woodrow Wilson
 in 1913 and holding his father's peace pipe. He visited us twice
 to pose and it was very exciting.

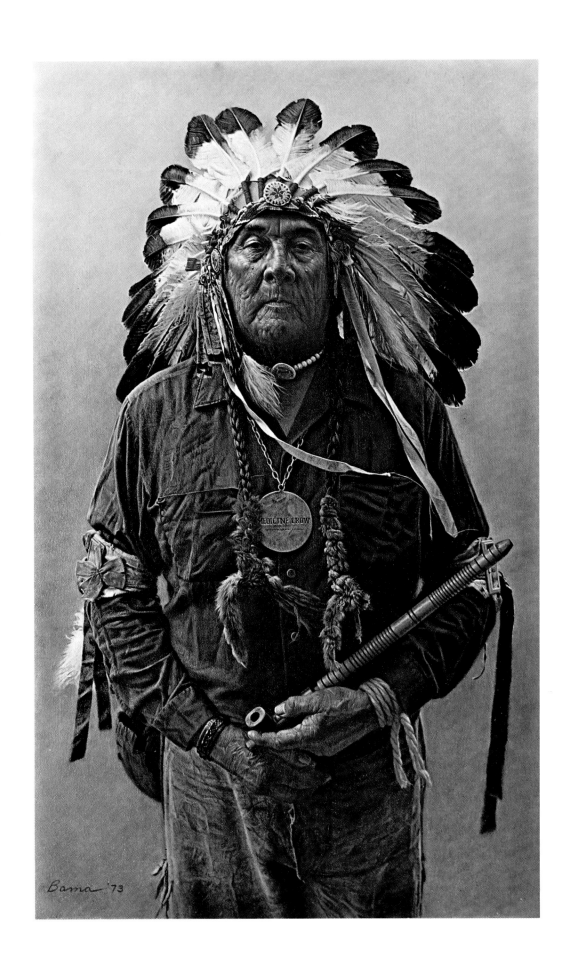

18) ROSE PLENTY GOOD—A handsome Crow Indian woman who made mocassins for one of the western stores in Cody, Wyoming. She was important in the tribe and arranged for all the other Crows to pose for me and drove them down from the reservations and back.

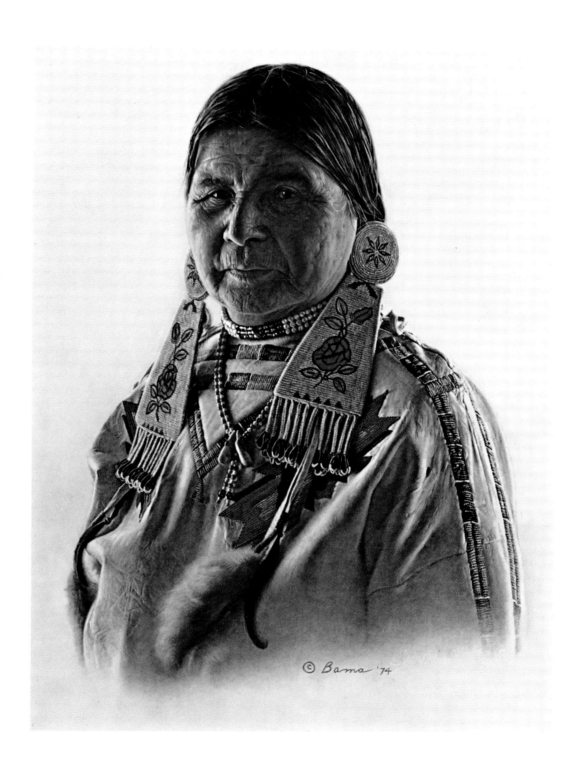

© Bama '74

19) CHESTER MEDICINE CROW IN HIS RESERVATION HAT—On the first of his two visits he wore his reservation clothes and his hat was typical of what I had envisioned. He also had on the traditional horsehair braids.

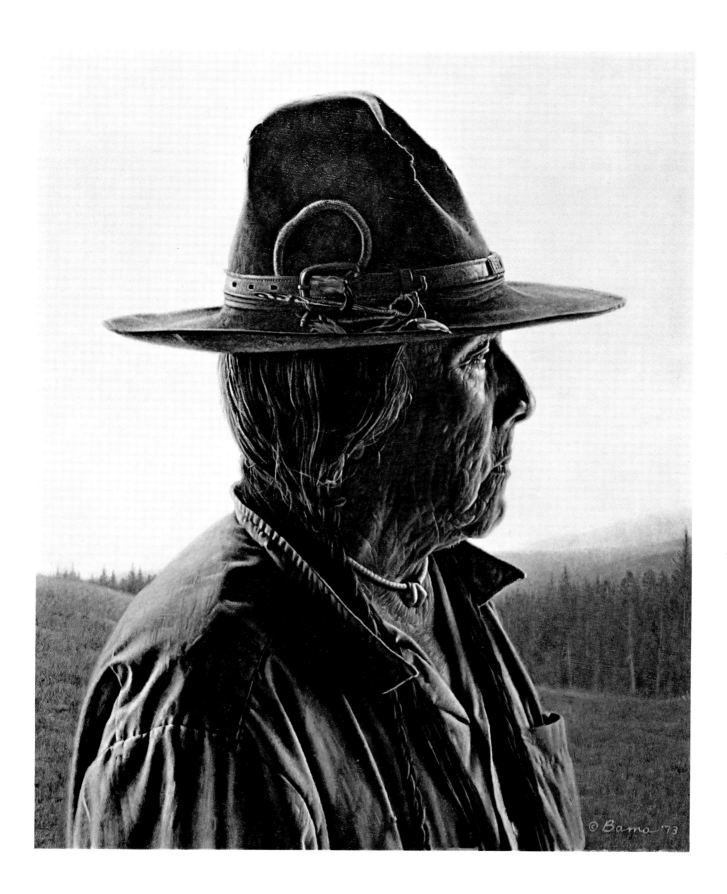

20) SHOSHONI CHIEF—His name is Herman St. Clair and I arranged to pose him. When I arrived he looked like an Indian version of William Bendix in "The Life of Reilly," but when he donned his tribal costume and headdress he became a noble Chief.

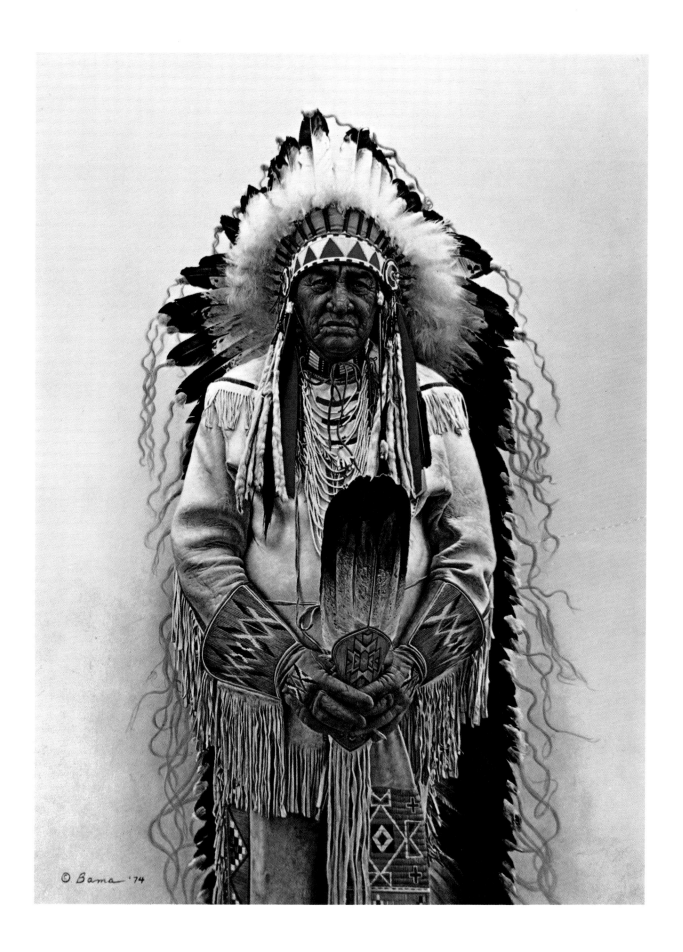

21) CHESTER MEDICINE CROW WITH HIS FATHER'S FLAG—The flag has 46 stars and dates back to the turn of the century. Chester carried it at the Crow Fair on horseback every summer.

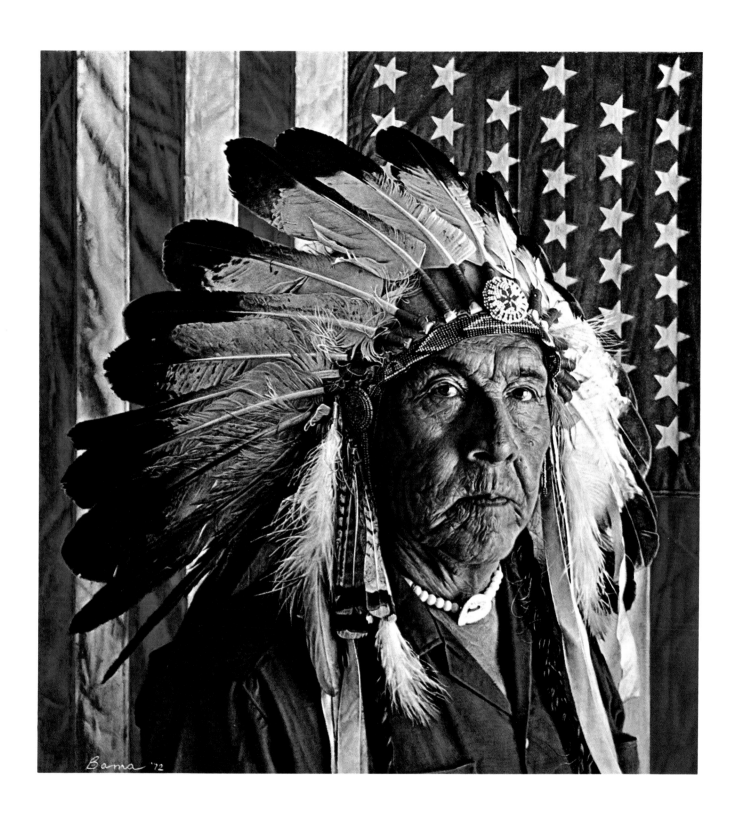

22) DEAN MOORE, DESCENDENT OF RED CLOUD—Part Irish, part Indian, he was a real professional cowboy, proud and independent. His dog was his companion. Thought his Indian saddle blanket would make the proper background.

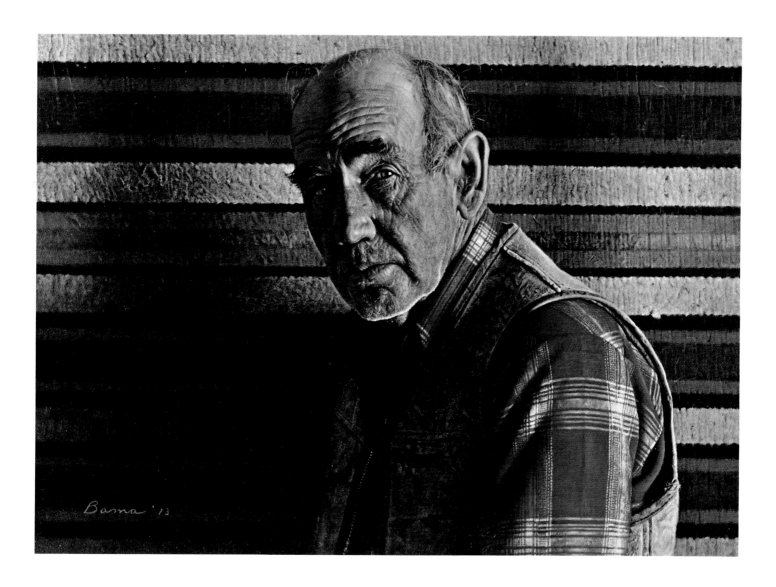

23) ANNIE OLD CROW—The older sister of Rose Plenty Good and a fine, delicate woman. A classic looking Crow Indian.

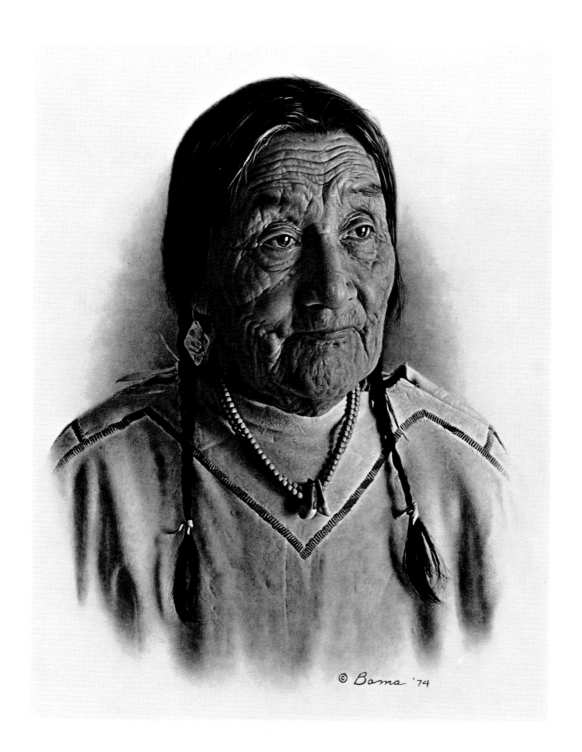

© Bama '74

24) THOMPSON'S CABIN—An old homesteader's cabin with a sod roof, down by the river. It was a steep climb up and down, but worth it. Is a magic place.

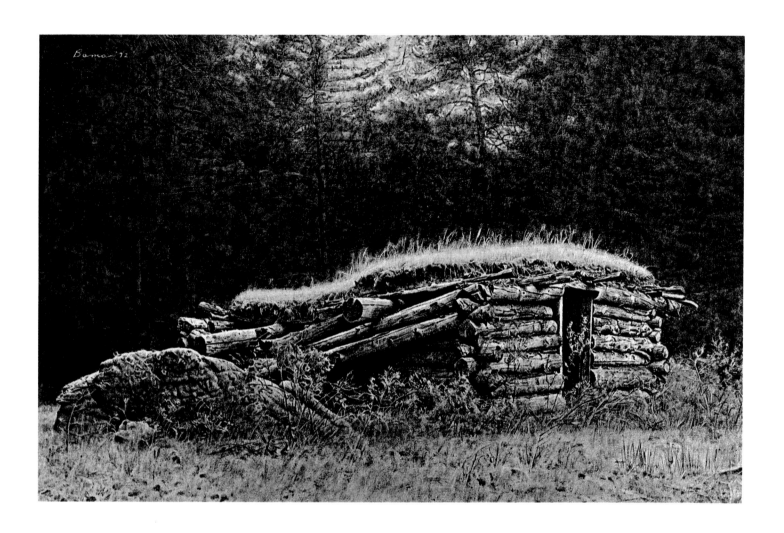

25) OLD TIME TRAPPING IN THE ROCKIES

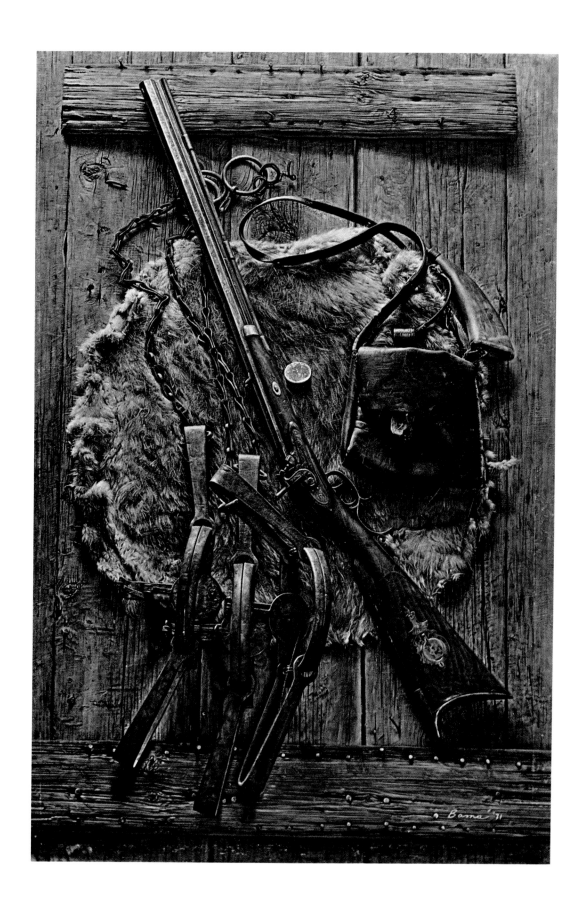

26) JERRY HODSON, COWBOY—A young cowboy who is a hunting guide in the fall. He went into the mountains for thirty-two days with two friends and posed for me before getting a haircut.

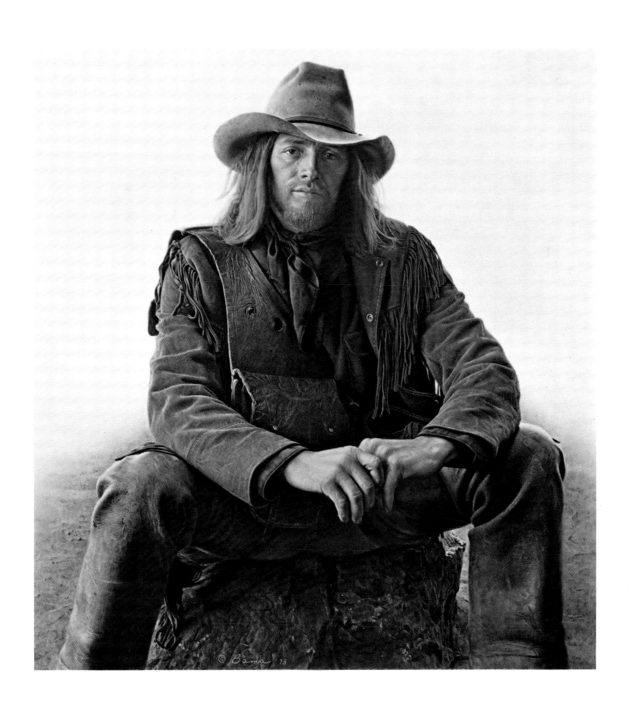

27) DEE SMITH WITH SADDLE BAG—A fellow artist who loves the mountains and has been a hunting guide since his 'teens. He made his saddle bag when in high school. He might have been happier if born a hundred years earlier.

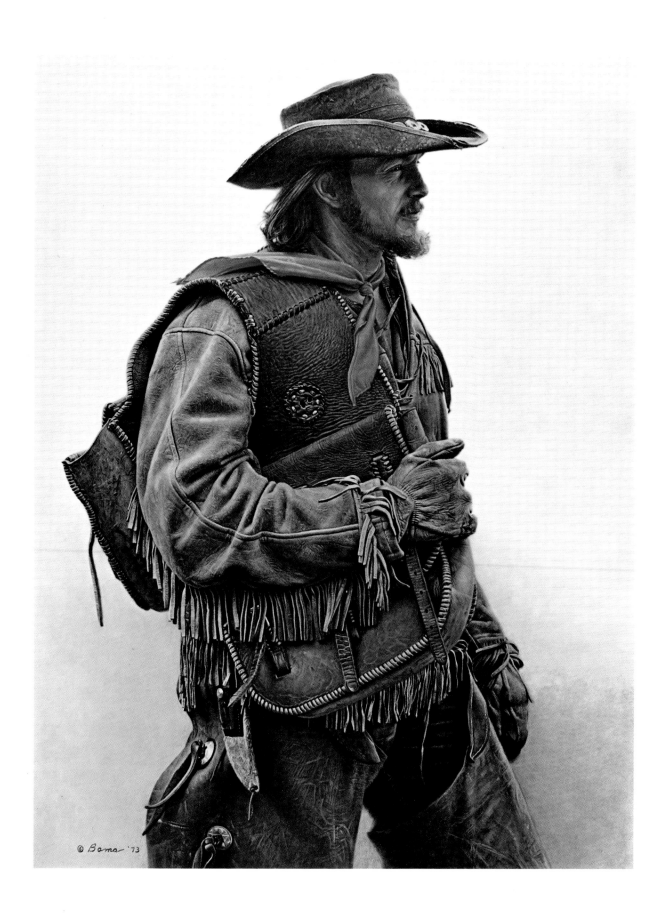

28) TOMMY THOMPSON, OUTFITTER—A transplanted Easterner for many years who prefers a hunting camp and the rugged life of the west.

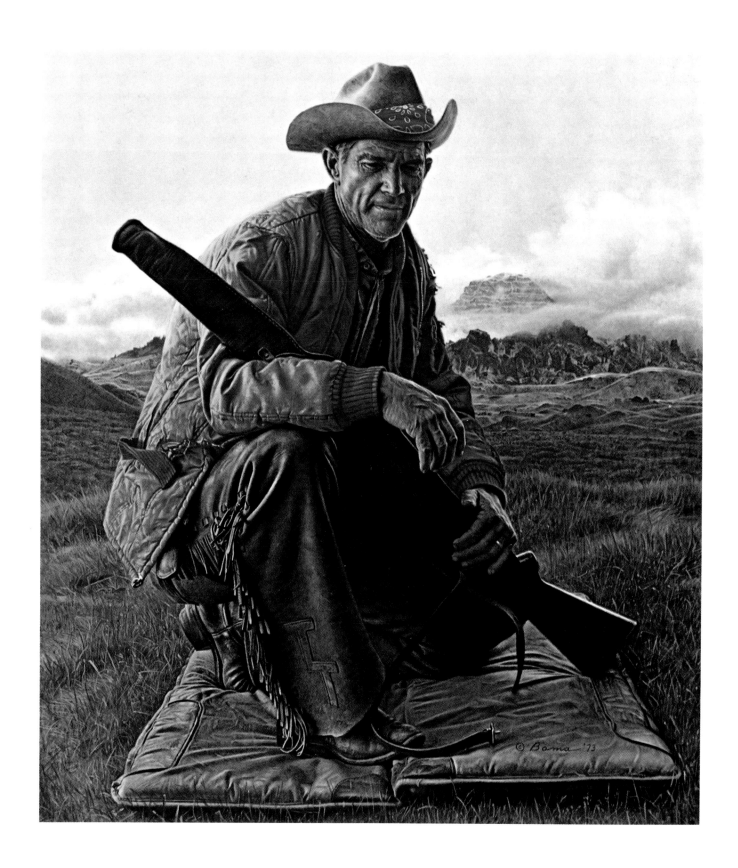

29) COWBOY IN YELLOW SLICKER—A handsome cowboy who ventured from Kaycee, Wyoming, to Cody, to try his hand at team roping.

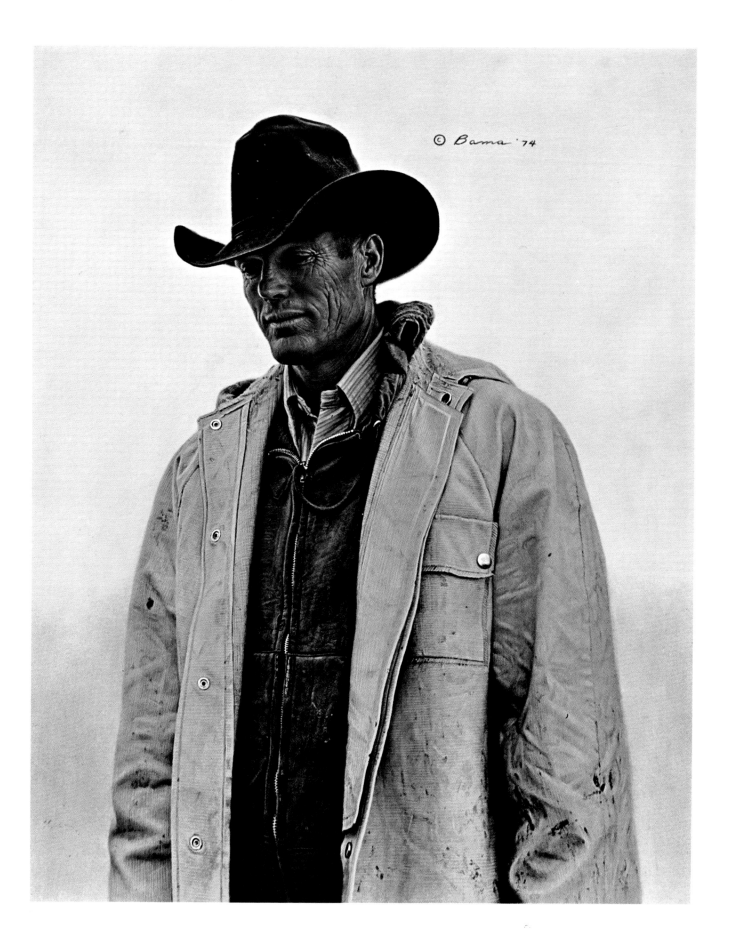

30) TONY MARTIN, HUNTING GUIDE—a nice young fellow who
 rode by my house during bear hunting season in the mist and
 rain in this wonderful poncho slicker. One of a breed of young
 guys who just wants to be a cowboy.

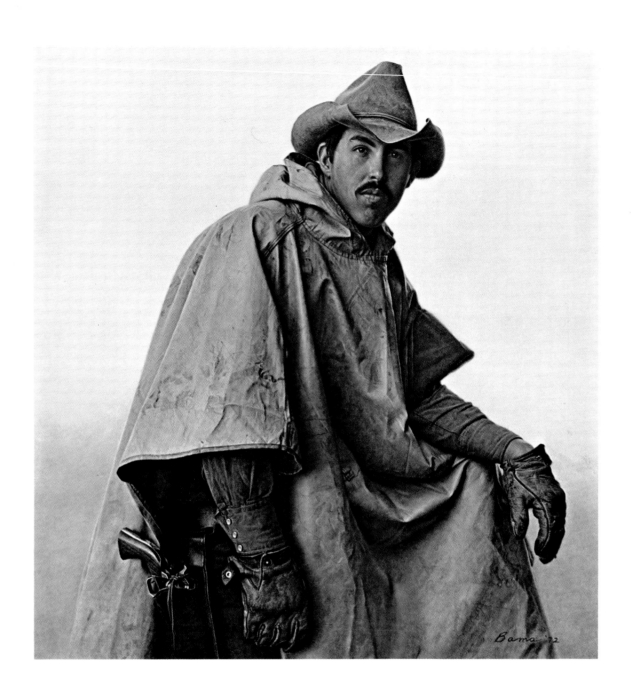

31) GARY FALES, OUTFITTER—A neighbor who outfits during hunting season, traps, breaks horses and rides in the rodeo, and has had bit parts in western movies. Born here, twenty-nine years old, with the hands of a fifty-year-old man.

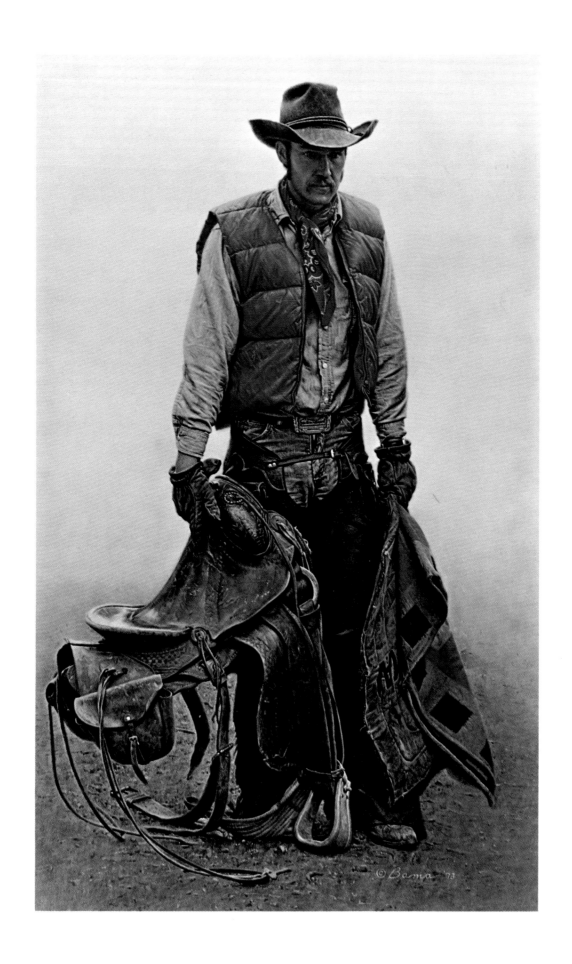

32) WAGONS IN WINTER

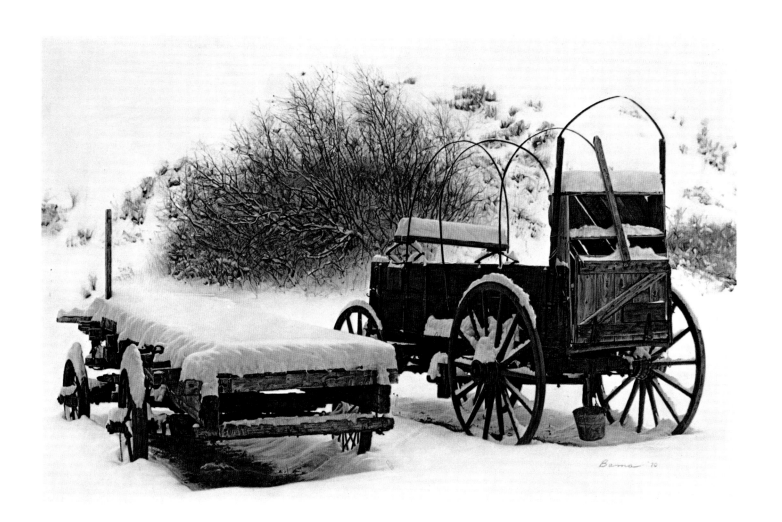

33) BERNIE BLACKSTONE'S OLD SADDLE—Thought it would be a good idea to do a portrait of a saddle which was eighty years old and unwanted.

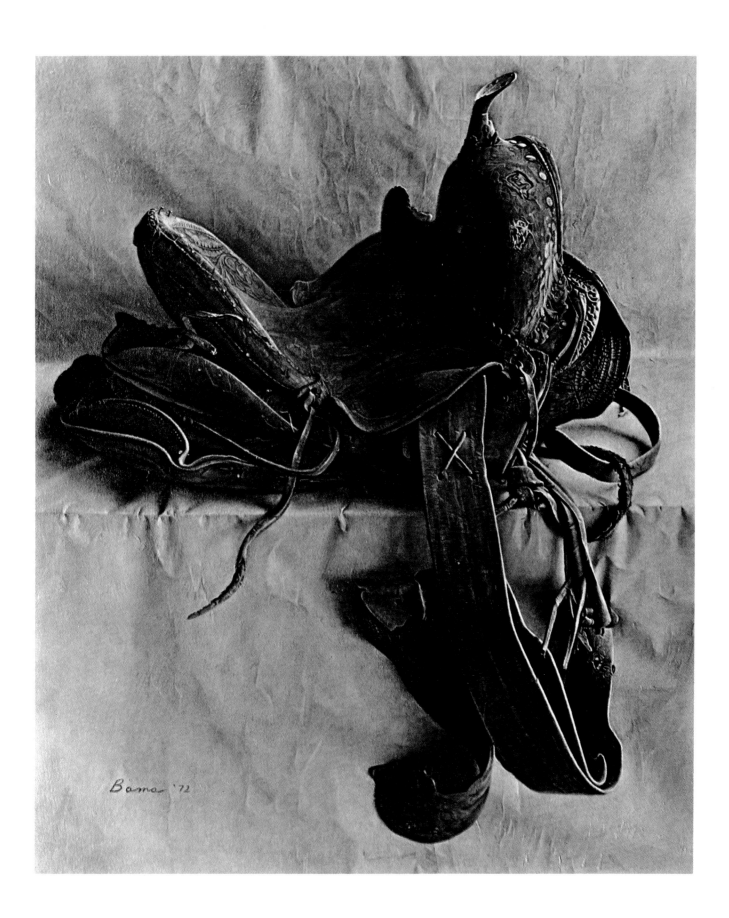

34) TOMMY MEYERS AND SAWDUST—Sawdust was a two-year-old horse who had never been staked out. He panicked and caught his leg in the rope at full gallop and had to be shot moments later. Tommy was comforting him while his father got the gun.

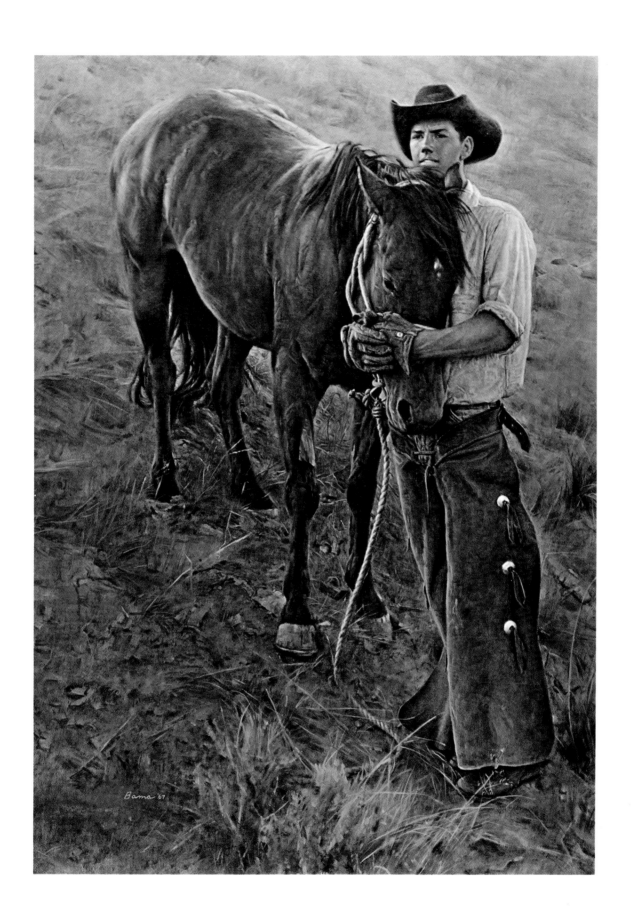

35) LYNNE AND THE DOGS—This was the first painting I did of my
 wife. A young horse had just broken its leg and was shot.
 You can sense the sadness in the dogs, too.

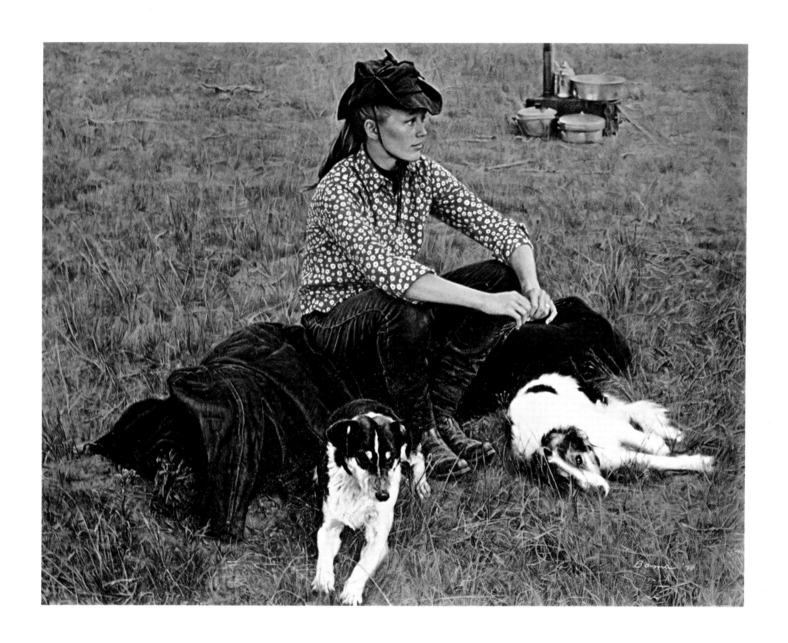

36) LYNNE BAMA WITH HAT—During hunting season everyone
should wear some bright red or orange so as not to be mistaken
for a game animal. That is the significance of the red kerchief on
the hat, which was her father's when he was a boy scout.

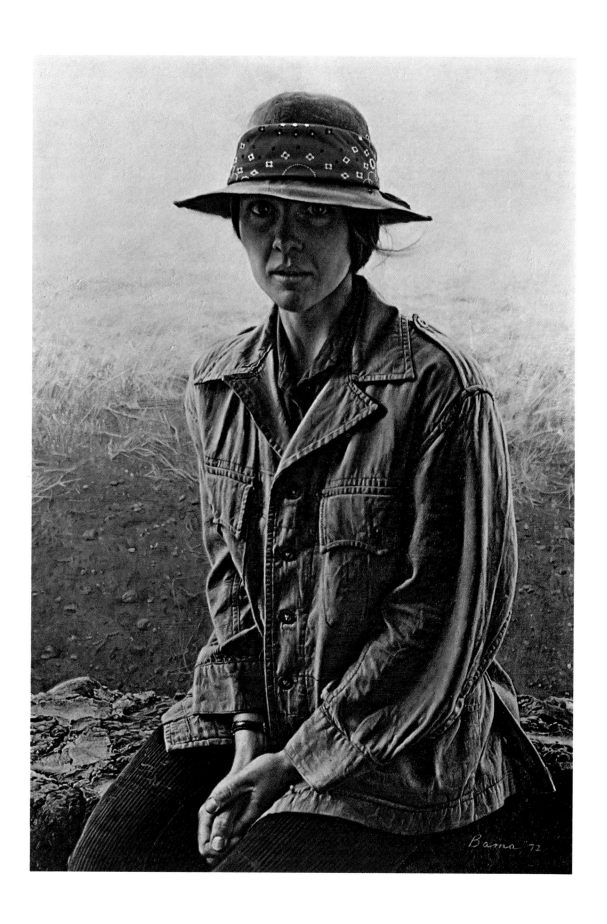

37) OLD SADDLE IN THE SNOW—A hundred-year-old saddle I
acquired. Set it out in the snow and waited several weeks. The
night the snow fell just right the temperature was minus 20°.

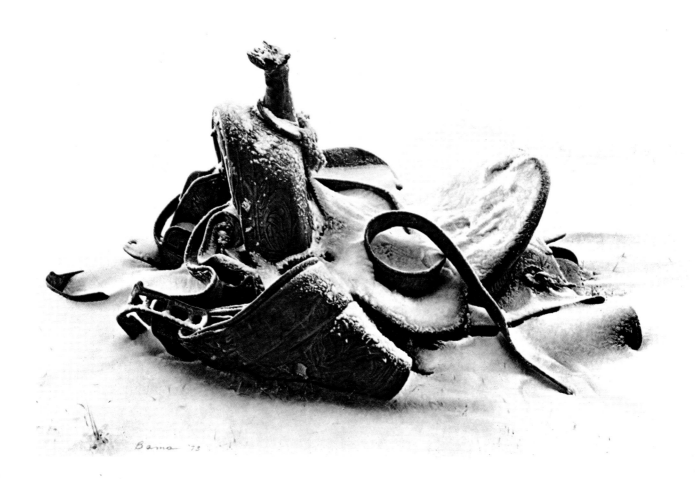

38) SLIM LIGHTING UP

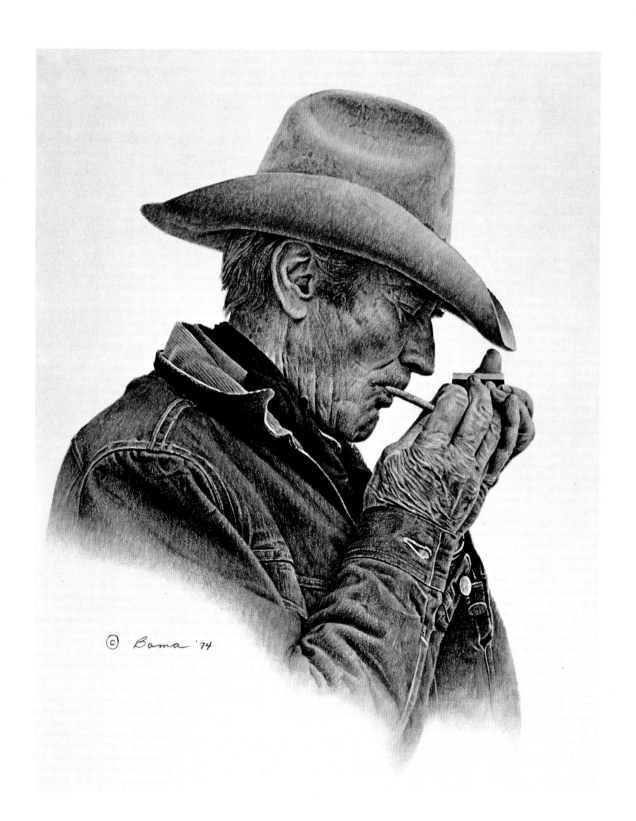

39) LEE PINCKARD, GUIDE—A typical hunting guide with a great
pair of old leather chaps. He was getting ready to take out a
pack trip of dudes.

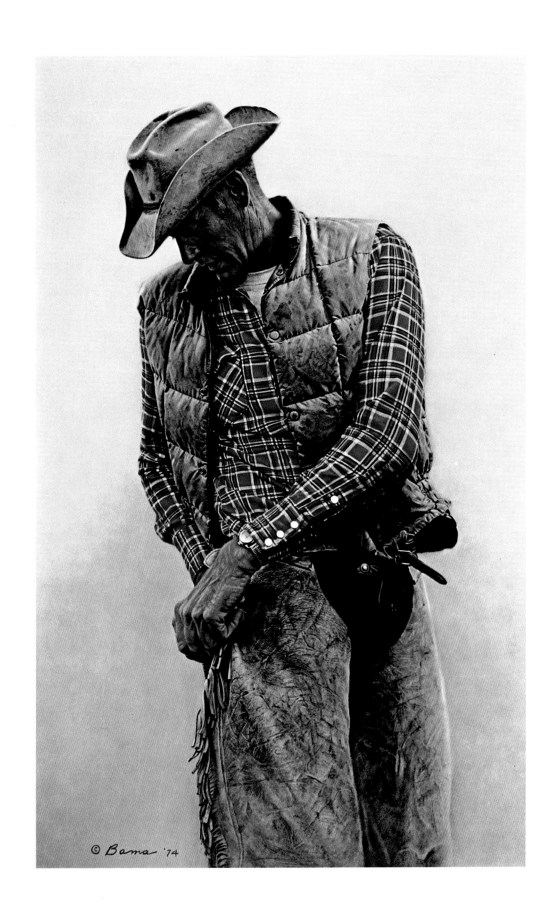

40) BILL SMITH-NUMBER ONE—World's Champion Saddle Bronc
 Rider in 1969, 1971, 1973, and revered in Cody, Wyoming, his
 hometown. He is also number one as a person, shy, modest and
 a gentleman.

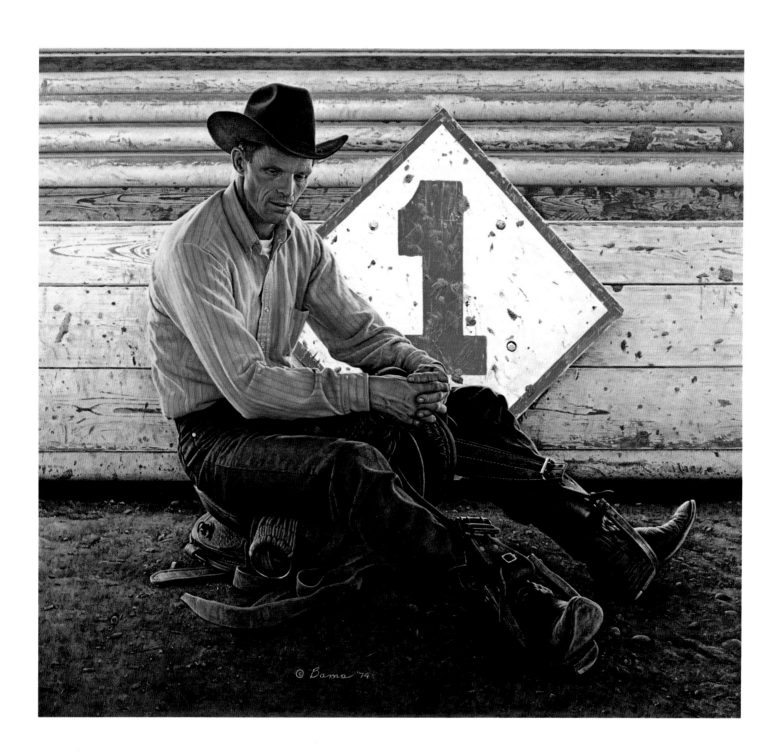

41) THE ROOKIE BRONC RIDER—He attended a school for bareback
 riders given by Joe Alexander, world's champion bareback
 rider. He is studying the stock.

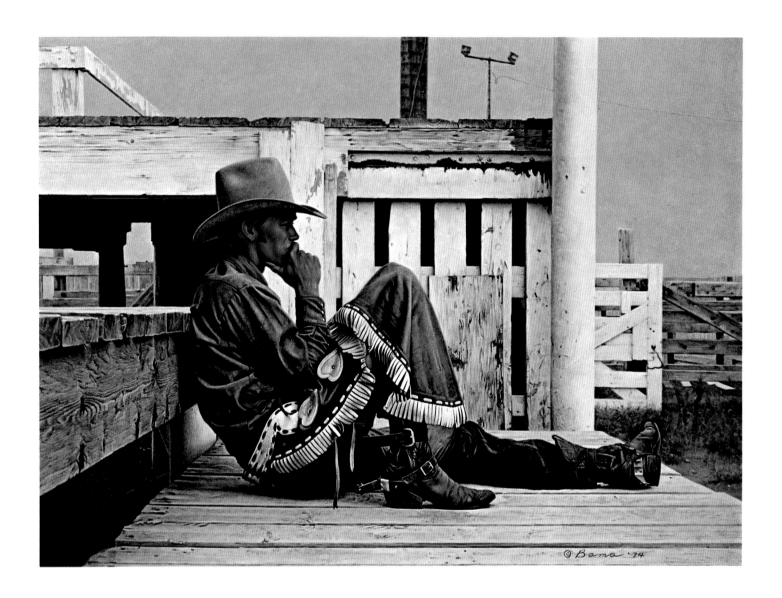

42) BRONC RIDER—A contestant in the High School Rodeo in Cody, Wyoming.

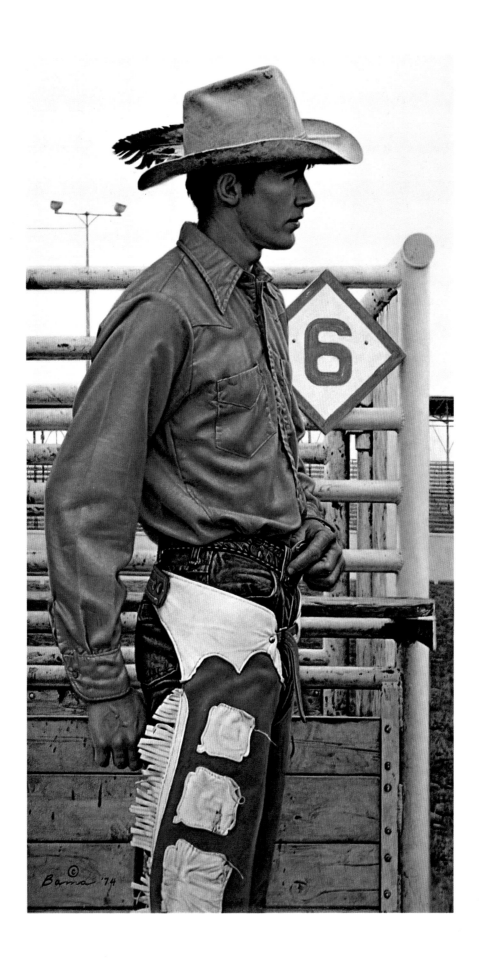

43) JOEL SIMS, HIGH SCHOOL BRONC RIDING CHAMPION—
Asked him to pose because of his polka-dot shirt, not realizing
he would win his event later that day.

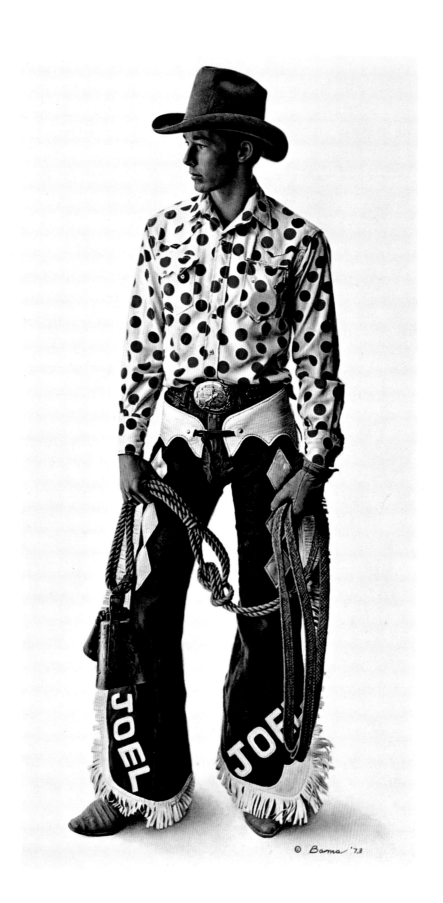

44) BELL IN WINTER

45) BOB RUMSEY'S PLACE—The pile of logs was the old cabin that burned down years ago. Waited three winters for just the right snowfall.

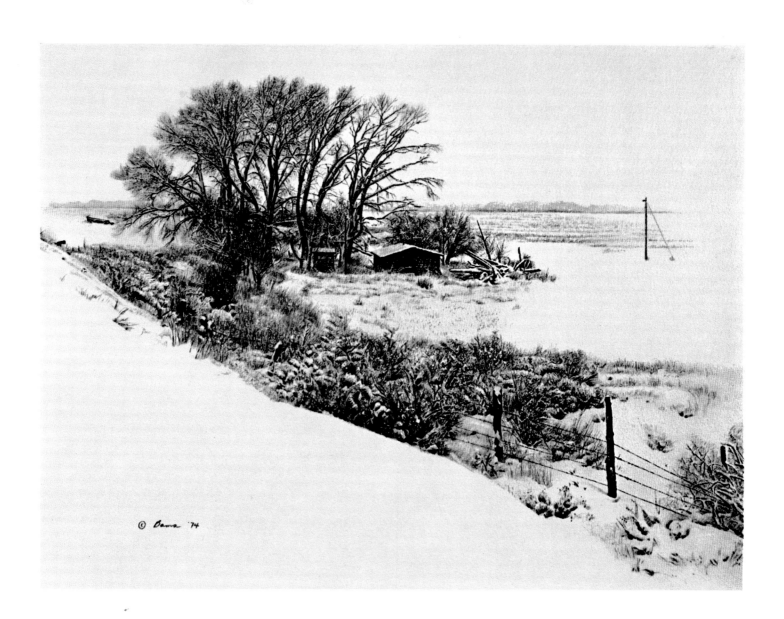